*AIRBRUSH*
*ARTIST'S*
*LIBRARY*

# *RENDERING*

# *METALS*

AIRBRUSH
ARTIST'S
LIBRARY

# RENDERING

# METALS

JUDY MARTIN

NORTH
LIGHT
BOOKS

This book was designed and produced by
QUARTO PUBLISHING PLC
The Old Brewery, 6 Blundell Street
London N7 9BH

**SERIES EDITOR** JUDY MARTIN
**PROJECT EDITOR** MARIA PAL
**EDITOR** RICKI OSTROV
**DESIGN** GRAHAM DAVIS
**PICTURE RESEARCHER** JACK BUCHAN
**ART DIRECTOR** MOIRA CLINCH
**EDITORIAL DIRECTOR** CAROLYN KING

Typeset by Text Filmsetters, London
Manufactured in Hong Kong by Regent
Publishing Services Ltd
Printed by Leefung-Asco Printers Ltd, Hong Kong

A QUARTO BOOK

Copyright © 1988 Quarto Publishing plc

First Published in North America 1989
North Light Books,
an imprint of F & W Publications, Inc
1507 Dana Avenue
Cincinnati, Ohio 45207

ISBN 0-89134-277-X

# CONTENTS

# RENDERING METALLIC EFFECTS

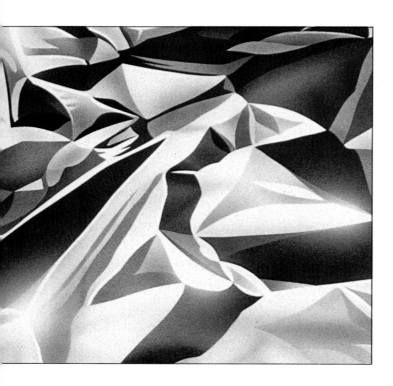

The surface effects of different types of metals present a considerable challenge to the artist. Many of their descriptive qualities are transient and elusive, changing with the light and reflecting color from their surroundings. Precise rendering of metallic surfaces is of particular importance in airbrush art because many of the subjects which feature in technical, editorial and advertising illustration involve hardware of various forms, from garden tools and kitchen utensils to aircraft and rocket ships. In fact, the glittering reflectiveness of the chrome parts of luxury automobiles has become one of the major trademarks of airbrush art: the flawless presentation of a highly finished airbrush illustration matches the brilliant allure of these coveted machines.

The main task of the artist in trying to render the surface quality of a particular metal is to make an accurate analysis of the component elements which together form that visual effect. More often than not, evolving a technical solution to a given problem is the easier part of the work. For example, apart from basic masking and airbrushing skills, the technique which occurs most frequently in the twelve examples

of different metallic effects demonstrated in this book is the simple process of scratching away the sprayed color to form highlight detail. However, the result of applying this technique is different in every case, each time producing a specific surface quality which enlivens the representation and, in several examples, provides the crucial finishing touch. Yet this is only one among a range of techniques which can form the solution to a given visual problem, providing that the required result is clearly identified in the artist's mind.

This analysis of form, tone, color and texture comes from close observation of the subject. Good reference material is essential, to provide descriptive detail of the metal. There are various conventions of airbrush imagery which can be used to assist the effect, but these remain static and contrived unless combined with authentic detail to round out the representaton. The shadows and highlights must model the character of the metal, its weight and general texture, as well as the surface effects of reflected light and color.

This book demonstrates various examples of metallic effects and the airbrushing techniques by which they are portrayed. To provide a basis for comparison, each metal is represented as a lettered plaque or as freestanding three-dimensional letters. The logo is designed in each case to take into consideration the physical qualities of the metal as well as its basic color, surface texture and degree of reflectiveness. In this way, certain typical features of the metal are described – the delicate neutrality of silver, the smoky coloring of brass, the heavy graininess of iron, the beaten texture of pewter. By following these exercises, various clues are obtained as to the basic attributes and temporary qualities which a particular metal may display, which provide the key to an analysis of the same material when it is presented in other contexts.

Metal objects are constructed and finished in various ways, and the substance itself may appear in different forms – white or red gold, for example, rather than the golden yellow tones which are immediately associated with this most valuable metal. Where a metallic effect is required in a particular piece of artwork, many elements have to be taken into account: the intrinsic qualities of the metal, the way it is cast or molded, the objects in its immediate surroundings which may cast shadow or tinges of artificial color onto the reflective material. While the guidelines provided in this book can form the basis of an effective rendering, the additional detail which will place the effect convincingly in a given context must always be considered independently for every project. The technical solutions proposed in these exercises will commonly be adaptable to similar problems in a different context.

To begin the process of masking and spraying an image, a clear, detailed trace drawing is always the essential first step. Only the outline is transferred to the support before the airbrushing begins, as is the case in all the examples demonstrated in the following pages (for reasons of space, the first stage of preparing the drawing is not always shown in the picture sequence). However, if the image is particularly complex, it may help to shade in roughly the main shadow areas and other details on the tracing, which can then be used as a key to the masking process as the work progresses. This approach is shown on page 56, with the initial drawing of the intricate surface effect of creased metallic foil.

## THE COLORS OF METALS

Much of the characteristic quality of a metal comes from its texture and the ways in which it is presented: in airbrush illustration, many elements contribute to an accurate rendering. The starting point is, however, the basic color of the metal to which tonal variations and color details are applied. It can be a difficult task to identify this precisely.

Color mixing is an important aspect of rendering metallic effects, but it is to a large extent a matter of trial and error. Different types of paint may yield a slightly different color balance, so the decisions must be practical, not based on formulas.

The panels on these pages show the basic colors mixed by the artist to portray particular metals. The orange-red hues of copper and dense gray of iron immediately stand out; it is less easy to differentiate steel and silver, brass and gold. The mixture used for gold is a fresh, clear yellow sprayed over sepia shadows; the color of brass is a little warmer and deeper in tone. Silver is a blue-gray which includes cobalt blue; it is a cooler gray than that used for steel, in which the blue content comes from ultramarine.

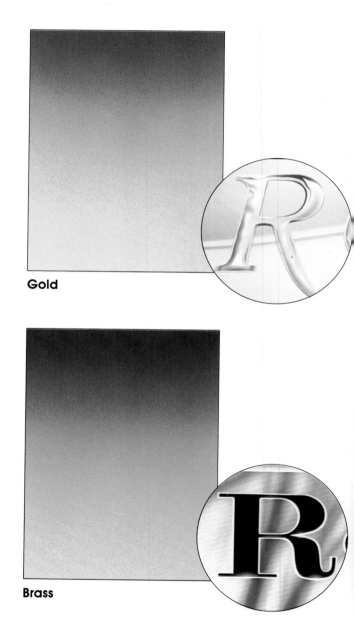

**Gold**

**Brass**

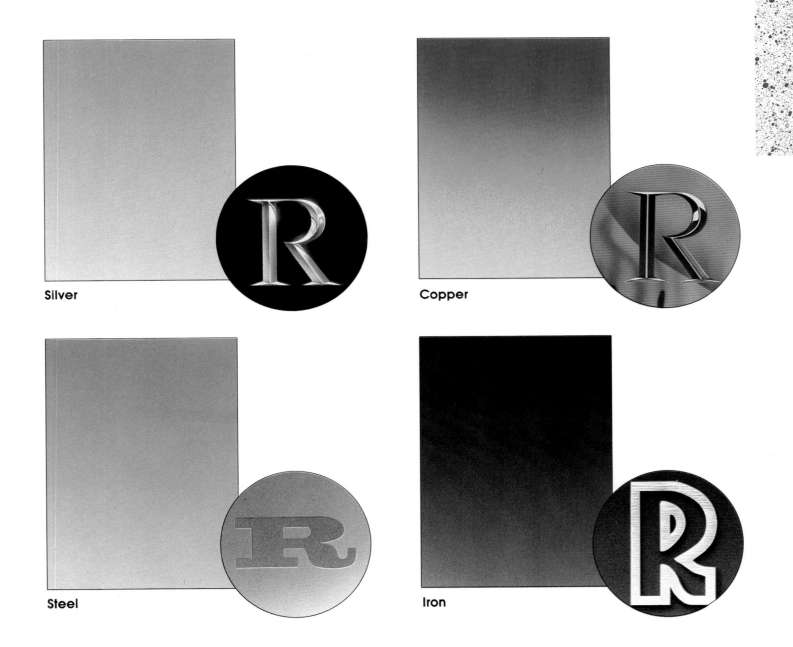

Silver

Copper

Steel

Iron

THE COLORS OF METALS

# GOLD:
# SURFACE MODELING

Gold has an effect like no other metal, even in purely visual terms, and it is impossible to avoid the associations of its status. It may appear in an image to convey luxury, wealth or power. It appears in many forms, from gilding to solid gold ingots, in red gold, which has coppery overtones, and white gold with almost the delicacy of silver.

This rendering uses cool yellow tones to depict a refined type of gold with a lustrous sheen rather than a brash glitter. The smooth, flawless surface of the elliptical plaque supports the lightly "cushioned" effect of the raised lettering. The minor irregularities in the surface of beaten gold are a part of its charm. The highlight areas are pure white, the shadows a subtle mist of sepia.

As can be seen from the picture sequence, this luxurious effect can be achieved by relatively simple techniques. A combination of masking film and loose acetate masking defines the basic shapes; a little careful freehand work is required to model the forms of the letters. The final highlight detail, creating a slight dazzle on the surface, is the element which brings the rendering to life.

Draw the logo and mask the full image area. Cut all the outlines of the letterforms and plaque. Lift the masking from the outlines of the letters. Spray the dark shadow areas with burnt umber **1**, creating solid color on the curves of the "R" and "O," and grading the tones outward **2**. Shade the tail of the "R"; allow the color to dry, then overspray the outline areas with yellow **3**.

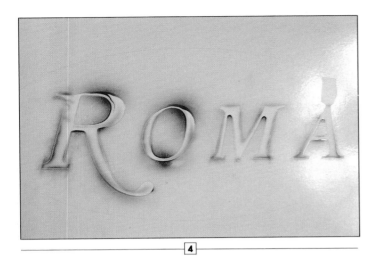

**4**

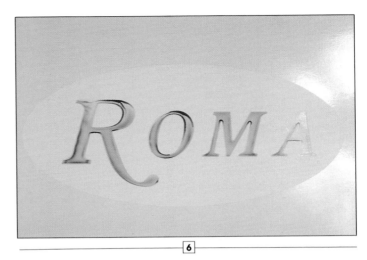

**6**

**5**

**7**

Remove the masking from the letterforms and spray lightly with burnt umber to create the mid-toned shadows within each shape, modeling the raised forms of the letters **4**. When dry, overspray all the letters with yellow, building up the color over the modeled shadows. Leave unsprayed highlight areas in the upper sections of the "R" and "O" **5**.

Allow the sprayed color to dry completely. Remove the masking film from the elliptical plaque surrounding the letterforms **6**. Mask out the letterforms with film and place a paper mask over the artwork **7**, cut to expose only the upper section of the plaque and the fine curved line of shadow running across the center (see the following page for positioning of the shadow line).

GOLD

Spray the upper section of the plaque lightly with burnt umber to shade the line across the center and the outer edges. Work in an elliptical movement, leaving a highlight area in the upper central section of the masked shape. Overspray the shadows with yellow to build up the gold effect, keeping the tones lighter than those in the letterforms so that the lettering stands out in relief against the background **8**. When the effect is complete, remove the paper mask, leaving the film masking in place over the letters and masking out the background around the plaque **9**. Spray the lower area of the plaque with yellow, forming a graded tone corresponding to the shadows in the upper section, leaving a central highlight area across the base of the "O" and "M" **10**.

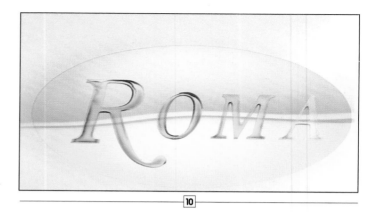

10

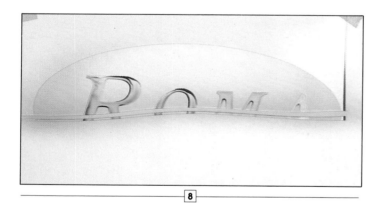

8

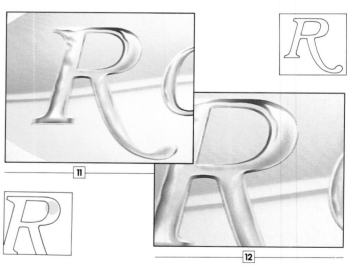

11

12

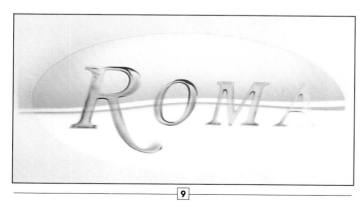

9

When the color is dry, remove the masking from the letterforms. Using the edge of a scalpel blade, scratch back the color on the shapes of the letters to enhance the highlight detail on the vertical strokes of the letters and the curves **11**. Spray small bursts of opaque white over the main highlights to give an effect of diffused light **12**. Follow these techniques on each letter, emphasizing the curves and angles of the forms. When the image is completed, remove all remaining masking **13**.

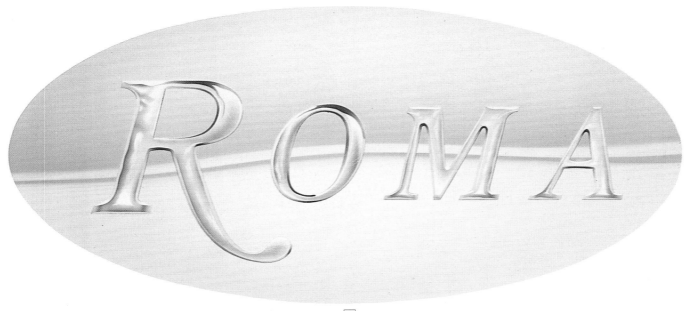

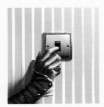

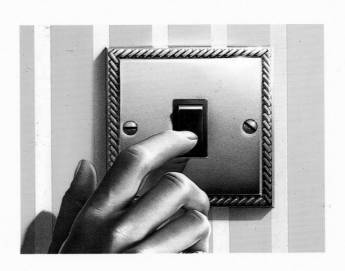

**LIGHT SWITCH (detail)** TOM STIMPSON
The gloved hand and golden light switch are rendered with
the classic techniques of airbrushing, a build-up of layers of
color forming the richness and depth of the surface effects,
finally modeled by scratched back and opaque white high-
light details.

# SILVER:
# HAND-PAINTED DETAILING

The flawless surface finish which can be achieved through airbrushing techniques is well suited to rendering the delicate, refined quality of silver. The colors of pure silver are not easy to identify: tones of neutral gray may produce too hard an effect; an over-emphasis on blue tints produces a surface almost indistinguishable from steel, while a bias toward yellow gives the impression of silver-gilt or white gold. The balance of tones must be carefully judged to reproduce the discreet elegance of silver, suggesting both the surface effect and the physical substance of the metal.

In this example, the sequence of masking and spraying with the airbrush creates the smooth, angular formation of the classical lettering and the polished surface sheen of silver. An important contribution is made to the final rendering, however, through the addition of hand-painted detail and highlighting created by scratching back the sprayed color. With these techniques a rippling "watermark" effect is formed and this, together with the soft dazzle of airbrushed highlights, gives the image its ultimate authenticity.

Draw up the logo in outline, showing the angles of the letter strokes and serifs. Cover the image area with masking film **1**. Cut the film along all the lines of the drawing. Remove the masking film covering the plaque, leaving the letters and background area masked. Spray the plaque with black, building up to solid color **2**. Allow to dry. Lift the small sections of mask representing hard-edged shadows inside the serifs and inner angles of the letters **3**. Spray with gray to form mid-toned shadows.

3

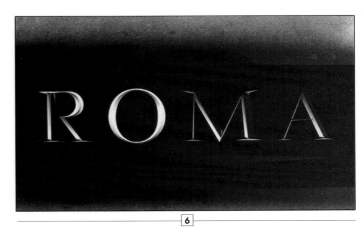

6

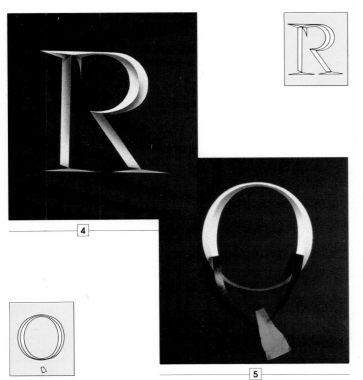

4

5

To model the angled shapes of the letterforms, lift each mask section in sequence and work with graded tones of gray, always spraying against the edge of a mask section to create the darkest, hard-edged areas **4**. Keep each piece of masking in place with a hinge of tape **5** while spraying, for easy replacement when the color is dry. Continue to lay in the angled strokes of each letter by alternate lifting and replacing of mask sections **6**. Spray the underlining device below the logo in the same way **7**.

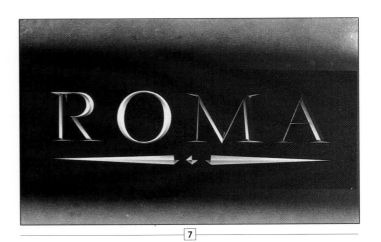

7

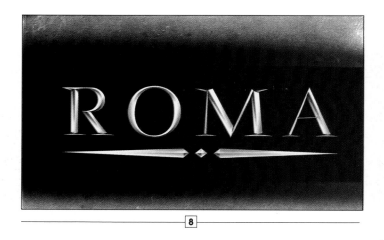

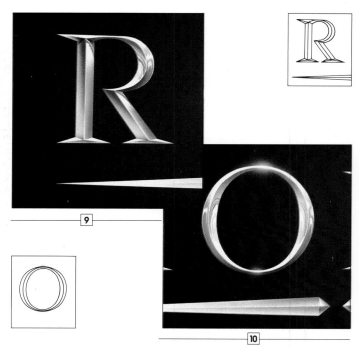

8

9

Spray lightly with blue-gray to create a bluish tinge in the mid-tones **8**. Remove remaining masking from the letters and scratch back rippling highlights with the edge of a scalpel blade. Apply corresponding shadows with a fine paintbrush **9**. Enhance the highlights by spraying small concentrated bursts of opaque white **10**, emphasizing the shiny effect of the metallic surfaces **11**.

10

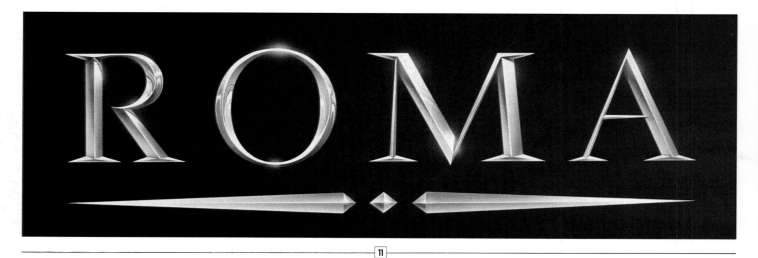

11

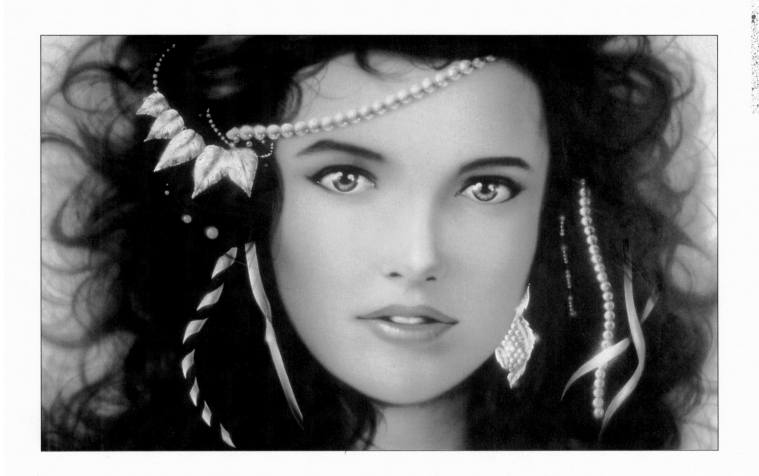

**THE PRINCESS** JONATHAN MINSHULL

A vividly decorative effect is achieved here in the silver and pearl ornaments using a close range of color and tone containing contrasting tints of soft blue and pink, given sparkle by the fine drifts of airbrush spray which create translucent white highlights.

SILVER

## COPPER: EFFECTS OF TONAL CONTRAST

The warm coloring of copper makes it more easily identifiable than certain other metals which share qualities of basic hue – the yellow tones of brass or gold, for example, and the cool grays of steel and silver. This exercise demonstrates the full richness of copper in the high tonal contrasts used to model the letterforms and the soft gradations of tone casting a luster over the flat surface of the engraved plaque. Copper also provides the often prized effect of the green patina which occurs with age or can be artificially induced by chemical treatment, an attribute hinted at in this representation by the complementary green shading at the corners of the plaque.

The angular roman capitals are modeled using hard masking to define the changes from light to dark tone. Loose acetate masks provide the softer transition between values of light and shade in the flat surface area. The overall effect is made coherent by a thin glaze of copper color sprayed across the whole image before the final details are added, imparting a warm luster which links the variations in surface quality produced by the masking and highlighting techniques.

**1**

**2**

**3**

___4___

___6___

Draw the image in outline and cover with masking film **1**. Cut the film along all the lines of the letters. Lift the sections of mask covering the heavy shadow on the angled sides of the letter strokes and spray with dark brown **2**. Lift the areas representing mid-tones and use the same brown to spray more lightly in these sections **3**. Overspray all the shadow areas with a glaze of copper **4**. Remove masking from the plaque **5**. Score a piece of acetate and tear to form an irregular curving edge. Place the mask inside each corner of the plaque in turn and spray with dark tone **6**. Hold the mask loosely to create a soft edge while applying the shadow as in the detail picture **7**. Score and break a piece of acetate to form a jagged-edged mask and spray dark tone. Using the curved mask, overspray a mid-tone **8**.

___7___

___8___

___5___

Place the curved acetate mask over the down stroke of the "R" and spray mid-tone in loose vertical movements **9**. Move the mask to a position over the top of the "O" and spray very lightly with brown. Work freehand to make a striped pattern of graded tones on the shadowed corner **10**. Overspray with a heavy glaze of copper; a mixture of orange, yellow and red forming a dark, warm orange **11**. Remove the acetate mask **12**. On each letter, spray mid-tone around the edge to diffuse the outlines **13**.

9

10

12

11

13

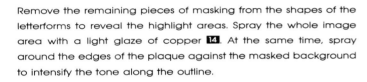

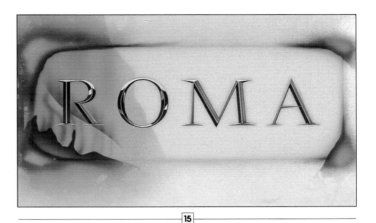

Remove the remaining pieces of masking from the shapes of the letterforms to reveal the highlight areas. Spray the whole image area with a light glaze of copper **14**. At the same time, spray around the edges of the plaque against the masked background to intensify the tone along the outline.

With the background masking still in place, spray freehand over the corners of the plaque with blue-green, representing the patina **15**. Leave enough of the dark tone visible to form shadowed edges against the copper glaze. When the color is completely dry, remove the background masking **16**.

# BRASS:
# SURFACE REFLECTION

As can be seen from the various stages of this picture sequence, the correct rendering of color and tonal values produces the basic surface quality of the metal, but the image remains flat until some additional detail is applied which enlivens the surface and brings out a distinctive character.

The essential hue is a heavy yellow based on yellow earth colors modeled over sepia tones to produce the simple three-dimensional form of the plaque. But it is the final addition of reflected tones, the smoky shadows and subtle drifts of white highlighting, which emphatically identify the "brassiness" of the object. In this context, the brass plaque suggests a doorplate shaded by nearby trees. In other renderings, while the base color would be the same, the reflective detail could be varied. A brass coal hod might have warm red shadows and strong golden highlights from reflected firelight, for example. This underlines the fact that the artist is required not only to observe the qualities of a metallic effect in the abstract, but to contribute the appropriate visual information which enables the viewer to read the context of the work.

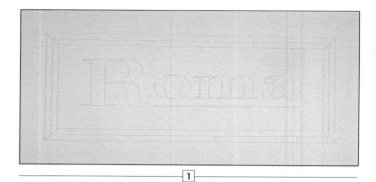

1

2

Draw up the image in outline on tracing paper **1**. Transfer it to artboard using transfer paper and mask the whole image area with masking film **2**. Cut the outlines of the design in the masking film. Hinge the top edges of the letterforms with adhesive tape, lift the masks, and spray with pure black **3**. When the color is dry, replace the masks over the letters. Lift the strip of masking film from the outer left-hand side of the beveled frame of the plaque. Cut an irregular curve along the edge of a piece of acetate. Tape the acetate loose mask in place over the unmasked section of the frame and spray lightly with sepia **4** to form a fluid shadow **5**. Follow the same technique to shadow the top edge **6**; reposition the mask between sprayings, overlapping the curves to form variations of tone. Cut new acetate masks and apply shadow to the right-hand edge **7** and lower edge of the plaque **8**.

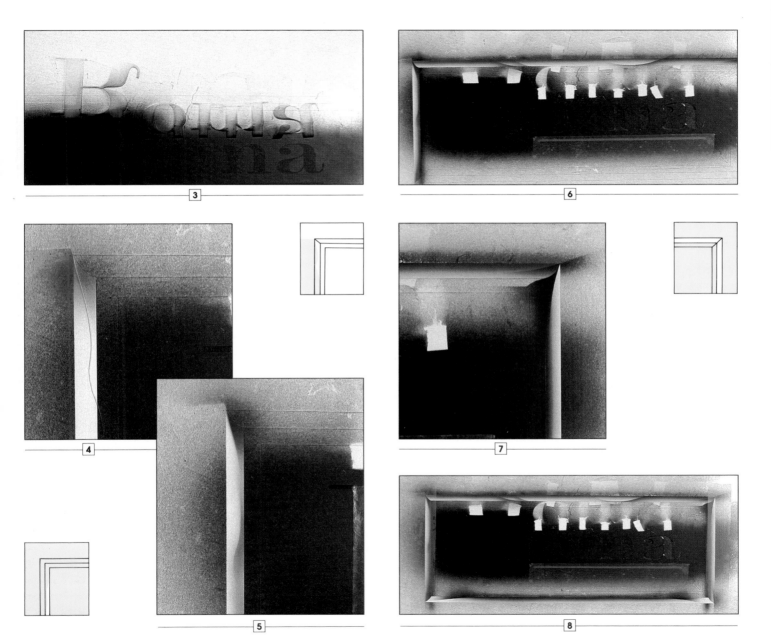

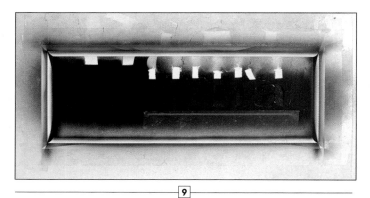

9

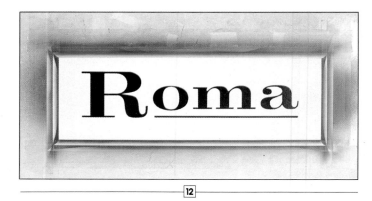

12

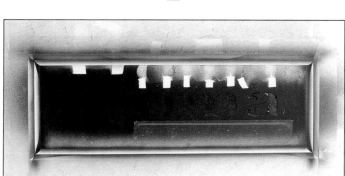

10

Mix raw sienna, yellow ocher and Indian yellow to make a rich, dark yellow. Spray this color over all four sides of the plaque, overspraying the shadow areas previously applied **9**. When the color is dry, remask the outer sections of the beveled frame and remove masking from the inner edges. Spray with sepia to form shadows of graded tone curving in toward the corners on each side of the plaque **10**. As the sepia tone dries, overspray each area wth yellow as before **11** to create the brassy coloring. Allow to dry. Remove the masking film from the flat surface of the plaque and place strips of masking film or transparent masking tape over the colored outer frame **12**, positioned so that it finely overlaps the unsprayed area of the plaque **13**.

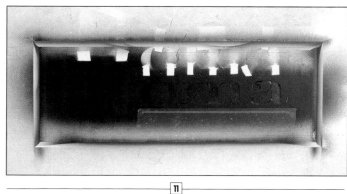

11

13

14

Remove all the strips of masking from the letters, but leave the strips of masking covering the edges of the plaque frame. Spray graded tones of yellow across the surface of the plaque, varying the density of the tonal values to create highlighting at each lower corner and across the center of the letterforms **16**. Remove the extra masking from the framed edges of the plaque, leaving only the basic outline of the whole shape masked. Spray again with yellow, building up the tone but maintaining the degree of variation across the surface to given an effect of light reflecting unevenly from the plaque surface **17**.

16

17

15

Place a strip of masking film or transparent tape over the top of the "R," allowing it to overlap the inner area slightly as shown in the detail picture **14**. Spray a light tone of sepia against the lower edge of the mask to form a slight shadow. Work in the same way on the horizontal strokes and main curves of each letter, and the underline, to form a shadow effect across the whole logo **15**.

Use the edge of a scalpel blade to scratch back highlights around the shapes of the letters, forming an effect of embossing. Use the highlighting to emphasize the horizontal forms of the letters; the cross-bars, curved bowl and base serifs of the "R," as shown in the detail picture **18**. Enhance the highlighting by spraying a small burst of opaque white over the line highlight **19** and using the same technique, apply a similar effect at the lower left-hand corner of the plaque frame.

Work in the same way to create highlighting across the whole of the logo, scratching line highlights on the curved strokes and base serifs. Add sprayed opaque white highlights to the bases of the letters **20**. Remove all the masking from the image and apply fresh masking film over the whole surface. Cut the film around the letterforms to overlap the edge of each letter by about 3mm (⅛in) all around. Cut around the outline of the plaque and lift the film from the center, leaving letters and background masked **21**.

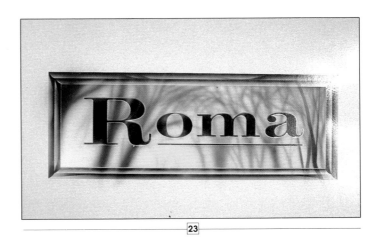

Cut a finely curving "tree branch" shape in a piece of acetate. Position the loose acetate mask over the right-hand side of the plaque and spray with graded tones of sepia to form branching lines overlaying the flat tone beneath **22**. Allow the sepia spray to form a hard-edged shadow of mid-tones.

Work with loose masks and freehand spraying to develop a network of overlapping branch shapes suggesting the reflection of nearby trees on the plaque surface; then spray lightly with white near the left-hand and top edges, to suggest reflected daylight between the branches **23**. Remove all remaining masks **24**.

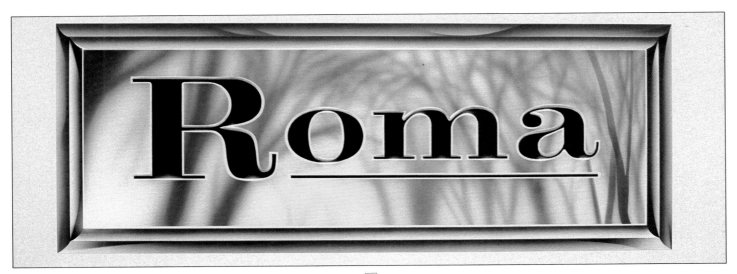

**ALCHEMY** JOHN BRETONA

In this image of magical transformation, fine linear highlights in the silver eggshell were created using glasspaper to scratch out the dark blue-gray; soft lights were brought up by rubbing with a pencil-type hard eraser. The hallmark in the golden egg yolk shows flat and spattered tones were sprayed through a finely cut mask.

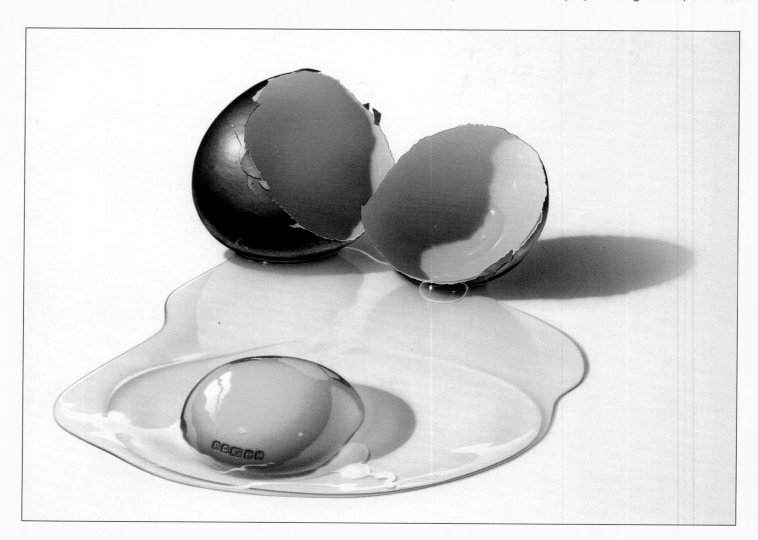

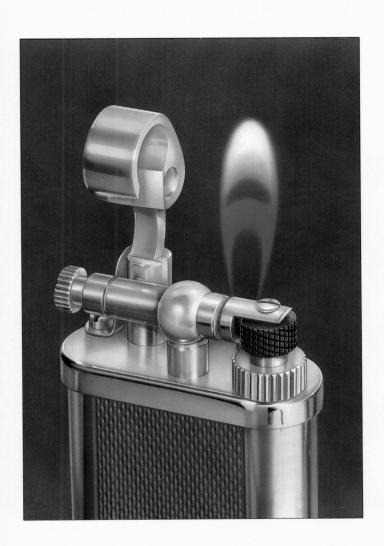

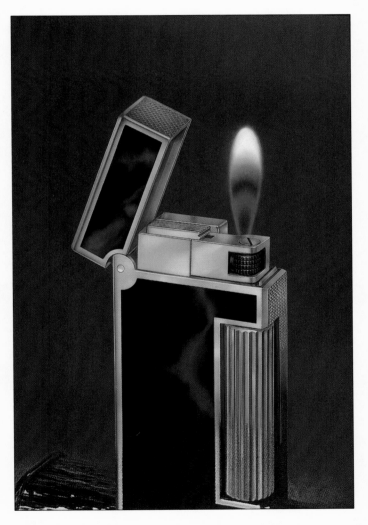

**DUNHILL LIGHTERS** BERT WARNER

These beautifully accurate renderings demonstrate the importance of color analysis in achieving the true effect of a particular metal. Clear yellow and orange tints laid over delicate blue-toned shadows produce the heavy golden effect, while a subtle range of pale but warm tints recreate the fine elegance of rose gold.

SURFACE EFFECTS

Draw and mask the image. Cut along the outlines of the letter-forms and hinge the top edges with adhesive tape. Lift and turn back the mask on each letter. Spray with a spattered tone of blue-gray **1** to create an even texture across each letter **2**. Overlay layers of spattering to build up the strength of tone. Lift the line of masking on the bottom and right-hand edges of the plaque and spray evenly with a slightly darker tone of gray **3**.

## STEEL:
## SURFACE SHEEN

The simplest techniques of the airbrush artist's range yield a highly sophisticated result in this rendering of a polished steel plate with lightly etched lettering. Steel is a ubiquitous material which appears in many different guises, depending upon its uses as a manufacturing component. In this example, a characteristic finish is achieved by applying soft blue-tinged tones with a narrow range of gradation — there is no black or white area among the tonal values — which impart a subtle surface sheen rather than a high polish. The difference in basic color between steel, silver (in some forms), aluminum and polished iron is not easily identified, but the context in which it is used in a piece of artwork and the details of surface finish can be brought into play to emphasize the metal's intrinsic qualities.

The three-dimensional form of the lettering is extremely shallow and the shadowed outlines are described very simply with a pencil line, offset by equally fine linear highlighting. The grainy texture of the letters is achieved by using a coarser quality of airbrush spray to contrast with the flawless surface of the flat plane on which they are displayed.

1

2

3

Replace masking on the letters and lift the mask from the plaque. Spray with graded tone **4** and repeat to build up the color **5**. Remove masking from the letterforms and use a pencil to apply fine dark shadows on the top edges and left-hand verticals **6**. Scratch back highlights on the remaining edges with a scalpel blade **7**. Remask the plaque and spray with alternate flat and spattered tones **8**. Remove masking and reinforce highlights **9**.

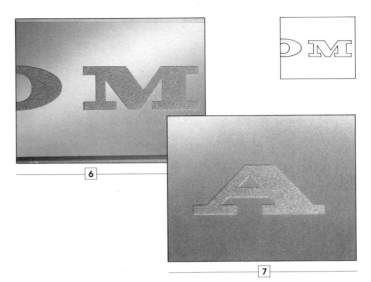

**6**

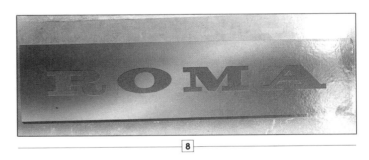

**7**

**4**

**5**

**8**

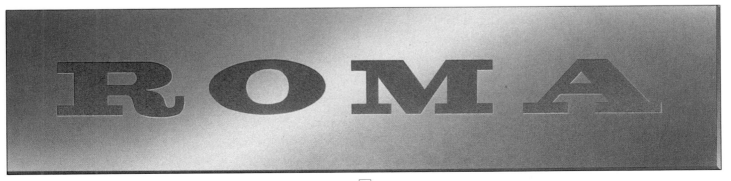

**9**

# IRON:
# GRAINED AND POLISHED TEXTURES

Unlike the precious metals, iron does not suggest any qualities of refinement and delicacy. It is associated with strength and solidity, as reflected in the weightiness of the iron bar on which the logo is embossed in this exercise. There is a rawness to the substance which can be disguised by surface treatments, but it is essentially a working, industrial material, not a decorative element. For this reason when iron is used to provide ornamentation, such as the tracery patterns of wrought iron, it is often given a glossy paint finish to complete the effect.

This airbrushed example makes use of spray technique and hand-worked detail to demonstrate the different types of grained surface which iron may display. The solid bar on which the letters are formed is treated with a spattered texture suggesting the slight roughness of the the surface grain. Scratched highlighting on the cool gray of the embossed letters provides a horizontal grain to the more polished finish. The technique is similar to that used for brushed aluminum (see page 50), but a direct comparison shows how the basic technique has been adapted to the precise effect required.

1

2

Draw up the logo and apply masking film to the image area. Cut the film along the outlines of the drawing. Remove the strip of film across the lower receding plane of the plaque and spray with a graded tone of black. Lift the mask sections on the angled edges of the letterforms and spray with black **1** to establish the three-dimensional form of each letter **2**.

3

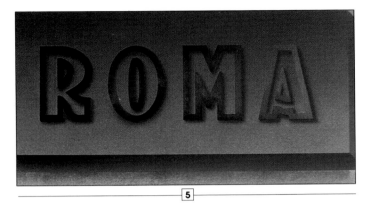

5

4

6

Lift the strip of masking film from the right-hand side of the plaque and spray with a graded tone of gray **3**. Remove the fine pieces of masking from the inner and outer edges of the vertical and diagonal strokes of the letters, as shown in the detail picture **4** and spray with graded tones of gray to establish the mid-tones in the three-dimensional modeling of each letter.

Overspray the lower and side edges of the plaque with a solid gray tone. When dry, cover these areas with masking film or low-tack tape. Remove all the masking from the flat plane of the plaque and spray lightly with blue-gray across the whole surface, shading from the top of the rectangle **5**. Spray mid-toned cast shadows echoing the shapes of the letterforms **6**.

IRON

7

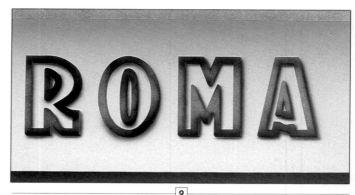

9

8

10

Remove the masking from the edges of the plaque, leaving only the background and solid outlines of the letterforms protected by masking film. Spray a fine spatter of gray over the whole image area **7**. Use a spatter cap or lower the paint/air ratio in the airbrush to produce coarser particles of spray, giving a gently speckled effect as shown in the detail picture **8**.

Mask out the shadowed edges of the plaque and apply alternate layers of smooth and spattered gray tones to build up the density of color **9**. When the effect is satisfactory, spray a fine spattering of white over the whole area, as shown in the detail picture **10**, to lift the surface quality of the sprayed texture, giving a slight luster to the dark coloring.

Remove the masking film from the letterforms and spray a graded tone of blue-gray **11**. When the color is dry, use a scalpel to scratch back fine edge highlights and create a horizontally striated texture across each letterform **12**. Finally, scratch a line highlight along the leading lower edge of the plaque **13**.

11

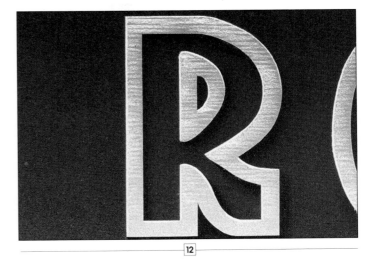

12

13

## CHROME:
## REFLECTED COLOR

Chrome is one of the most highly reflective of metals and its surface effect is invariably influenced by the colors of its surroundings. Because of this quality, there is a convention in airbrush illustration to represent chrome by means of a system of reflected color, the ground/sky scheme. The surface of the chrome object is divided roughly in half, creating a "horizon line." Above the line, the metal is shown as reflecting the colors of the sky, taking on blue tones; below the line the color is related to the ground, shown here as green, representing grass. Alternatively, this may be depicted as a warm earth color.

In this exercise, the forms of the letters create a complex distribution of ground/sky colors because of the curving shapes. The horizon line sometimes cuts across the form, at other times following the direction of the letter stroke. This means that the colors may alternate around the shape and in various areas only part of the masking is lifted while spraying a particular color; in other areas the mask section is completely removed. The masking method can be identified from details shown in the picture sequence.

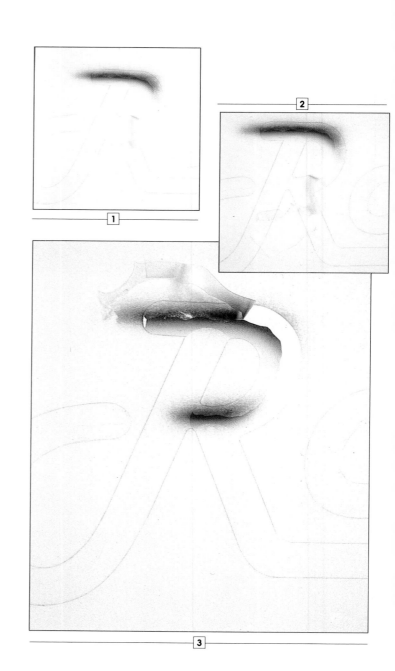

Draw up the logo in outline (refer to the finished image on page 34) and apply masking film. Cut the film along the outlines of the letters and on the horizon line running through the centers of the letterforms. Lift the masking on the "R" below the upper part of the horizon line and spray with indigo **1**. Overlay this with green, grading the tone downward **2**. Lift the piece of mask running under the curve of the "R" and and spray with indigo, then overlay with green **3**. Apply the same method to the looped end of the main letter stroke **4** and the bottom curve of the loop **5**. Allow the color to dry and replace the mask sections **6**. Lift the mask from the top inner curve of the "O" and spray with indigo **7**.

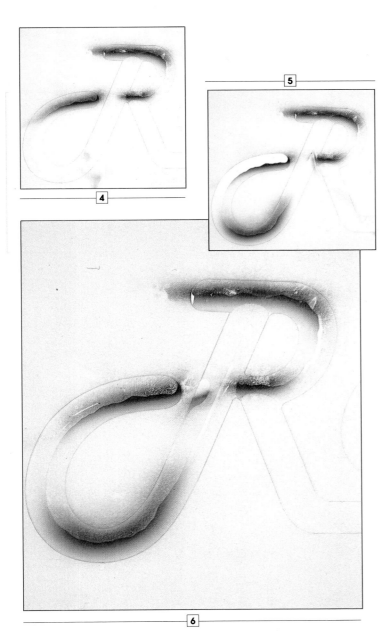

4

5

6

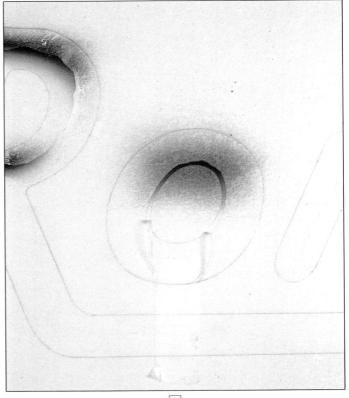

7

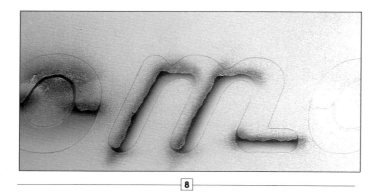

8

Remove the mask section on the letter "O" below the horizon line cutting through the letter strokes. Spray with indigo, and when dry overspray with green. Use the same principle to color the right-hand sides of the first two downstrokes of the "M" and the base of the third stroke **8**. Spray the curve of the "A" in the same way as that of the "O," and the base stroke in the same way as that of the "M" **9**. Replace the inner mask section of the "A" and remove the masking from the lower half of the letter. Color as before, with indigo oversprayed with green **10**. On the tail of the "R" running under the logo, spray the reflections of the letter bases **11** in the same way, then the full length of the tail **12**.

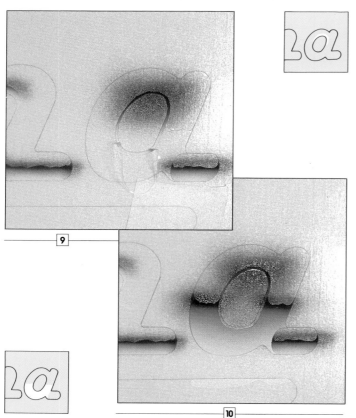

9

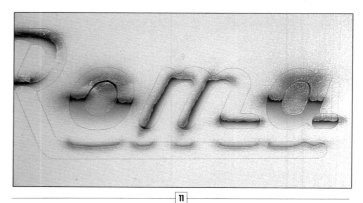

11

10

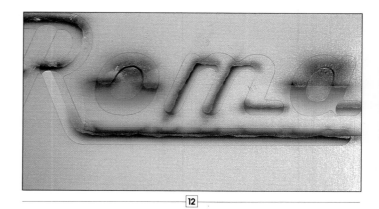

12

Return to the "R" and lift the masking from the inner curve. Spray with a graded tone of blue, working from the downstroke to the base of the curve **13**. Where the mask does not have to be completely removed from a section of the letter, turn back the appropriate portion and hold it in place with adhesive tape. Replace the mask and lift mask sections alternately in sequence to color the downstroke, loop and tail of the "R" with graded blue tones as shown **14**. Replace each piece of the mask as the area of sprayed color dries. Repeat to apply blue to the top of the curve **15**, and remove all the masking from the "R." Lift the mask section from the upper half of the "O" and spray with blue **16**.

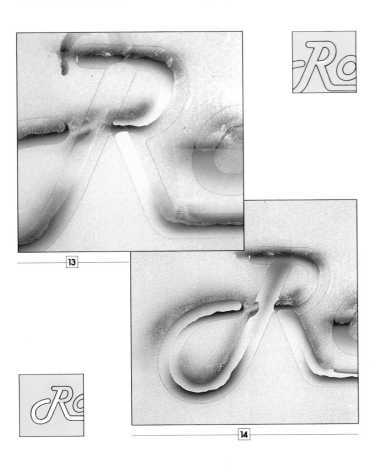

13

14

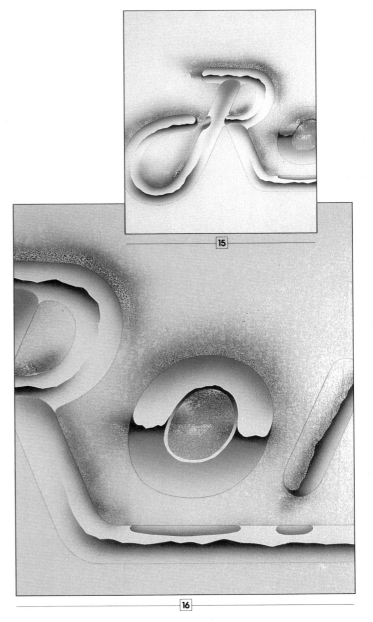

15

16

Repeat the masking sequence for each letter to apply blue to the "R" and "A" in the same way, then complete the coloring of the line beneath the logo **17**. Remove all masking and use a scalpel blade to scratch back line highlights on the top curves of the letters **18**, and on the downstroke of the "R" and the bases of "M" and "A." Charge the airbrush with opaque white gouache and spray a small dot highlight at the center of each main line highlight **19**. The final effect of the lettering shows the impression of a surface so polished that it takes its detail from reflected color **20**.

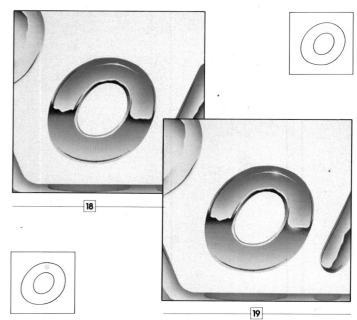

18

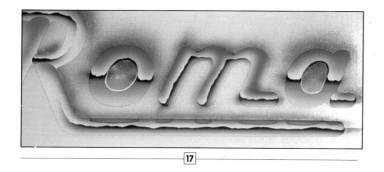

17

19

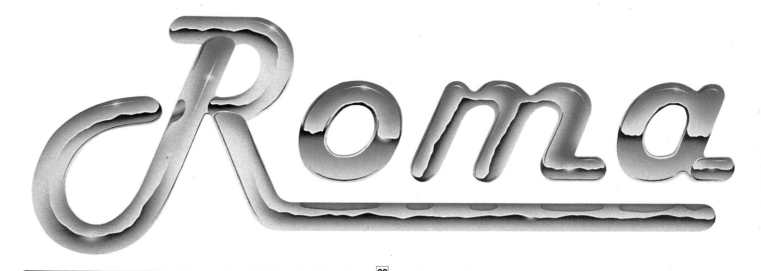

20

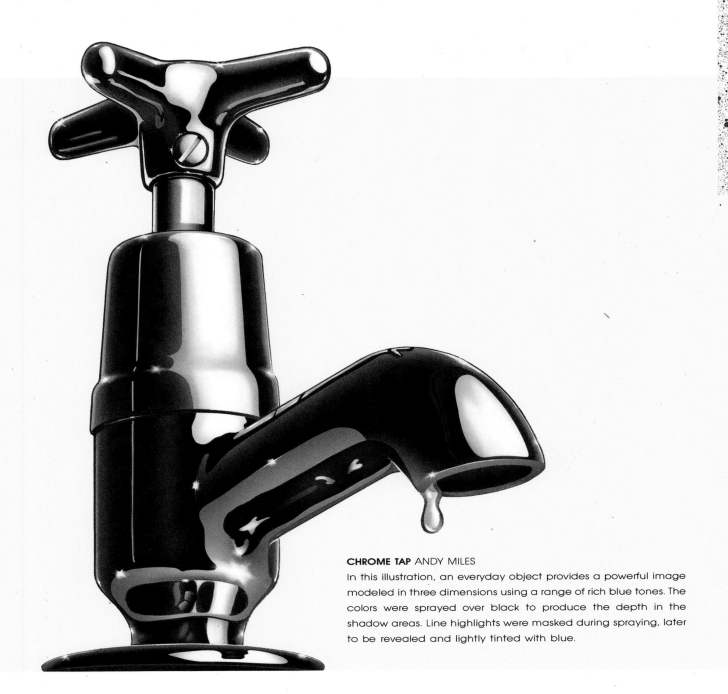

**CHROME TAP** ANDY MILES
In this illustration, an everyday object provides a powerful image modeled in three dimensions using a range of rich blue tones. The colors were sprayed over black to produce the depth in the shadow areas. Line highlights were masked during spraying, later to be revealed and lightly tinted with blue.

CHROME

**DARTS** ANDY MILES
**SAXOPHONE** PETE KELLY

Transparent overlays of clear yellow tones sprayed through paper masks produce the soft-edged ribs of color on the brass shafts of the set of darts. A different approach is taken to the image of a highly polished saxophone, which emphasizes a warmer tone in the metal with strong contrasts of shadow and reflected highlights.

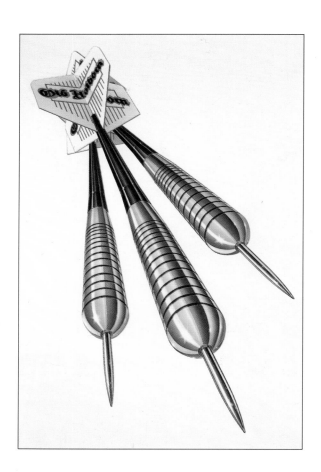

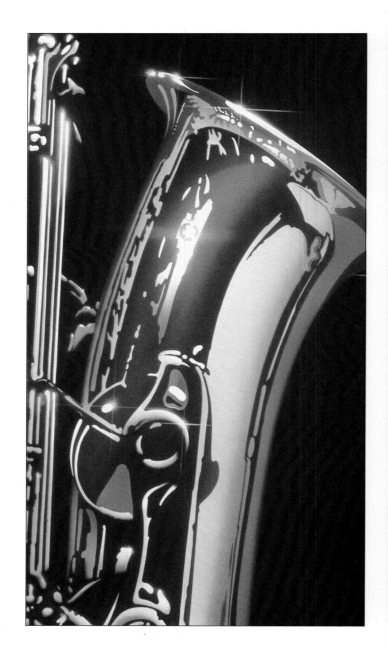

**42**

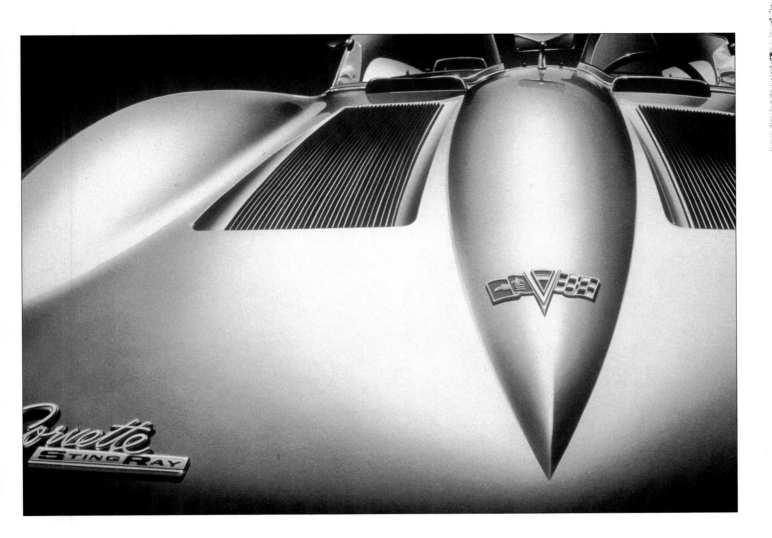

**STING RAY** GAVIN MACLEOD

The extraordinary sleekness of a flawless airbrushed surface serves to recreate the effect of this luxuriously styled, streamlined automobile. The sweep of light across the metallic surface is set against a gradation of tones formed by the range of cool grays subtly tinted with color.

# ALUMINUM:
# BRUSHED METAL EFFECT

Some of the relatively soft metal alloys are treated with a brushed surface finish which produces a finely striated texture running across the surface, a pattern of fine scratches interrupting the smooth metallic sheen. This finish is commonly applied to aluminum, and the idea of the brushed metal being used for display lettering inspired the design of the logo in this example, where the shadow letters suggest that the individual characters are mounted on struts against a flat background.

The main elements of the metallic effect are the subtlety of the gradation through light and shade interacting with the fine texture of the brushed surface. This texture is achieved by the process of scratching back the sprayed color, allowing the white support to show through the metallic grays. This technique can be carefully controlled to produce the right thickness of line — faint and irregular in the brushing, heavier and more even to highlight the angled edges of the letterforms. The surface polish is achieved by overspraying a semi-translucent layer of white which emphasizes the quality of reflected light without entirely masking the textural effect.

1

Draw the outlines of the letters and apply masking film **1**. Cut around the outline of each letter and lift the background masking. Using a trace of the logo, cut the letterforms in an acetate loose mask, reproducing the exact size and spacing and adding the diagonal bars joining the shadow letters to the main logo (see final picture). Tape the acetate mask to the artboard to overlap the original letters, forming a drop-shadow effect **2**.

2

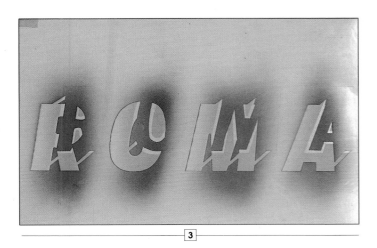

**3**

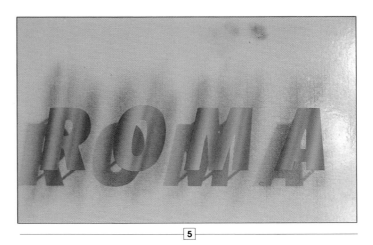

**5**

Charge the airbrush with sepia watercolor and spray graded tones across the acetate mask to form the shadow letters **3**. Strengthen the color by successive sprayings, increasing the grading of the tones from dark on the right-hand side of each letter to light on the left-hand side. When the tonal intensity seems satisfactory, remove the acetate mask and apply fresh masking film **4**. Cut and lift the film from the letterforms.

Mix a blue-gray tone and fill the airbrush paint reservoir. Spray vertically graded tones on each of the letterforms, building up the color gradually to balance the tone of the background shadows **5**. When the color is dry, use the tip of a scalpel blade to scratch back fine horizontal white lines cutting across the bands of graded tone **6**. Use a ruler to guide the knife blade and keep the lines very fine and closely spaced.

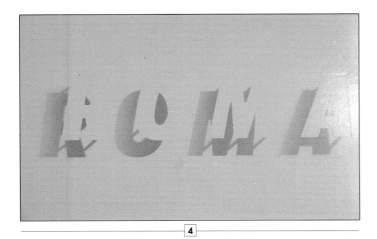

**4**

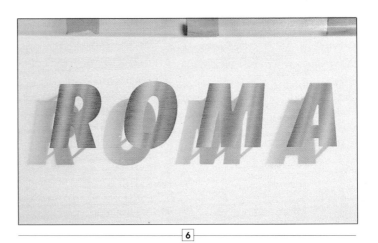

**6**

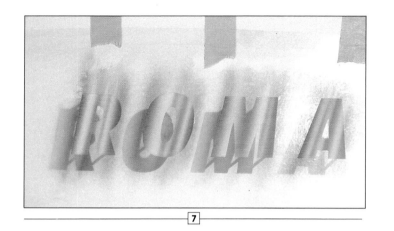

7

Charge the airbrush with white gouache and spray bands of highlighting vertically on the letter strokes, strengthening the effect of reflection from the metallic surface **7**. Do not apply the opaque white too thickly: allow the scratched highlighting to show through the sprayed highlights, as shown in the detail picture **8**. Remove all the masking film from the surface of the artwork. Use a sharp pencil to draw fine lines of shadow on the right-hand and lower edges of each letter **9**. With a scalpel blade, scratch back corresponding highlights on the left-hand and top edges of the letters. On the outer margins of the letter strokes, position the highlight slightly inside the outline of the letter as shown **10**. Use a ruler to guide the blade on straight lines; work freehand on the curves to complete the effect **11**.

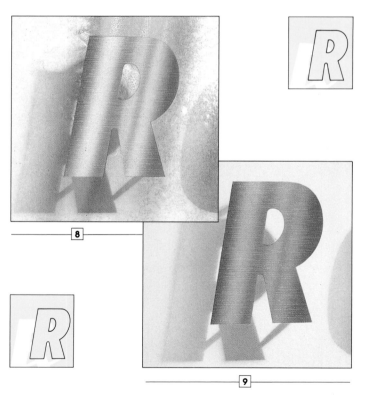

8

9

10

**46**

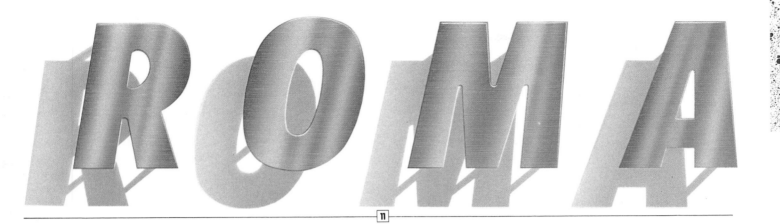

ROMA

11

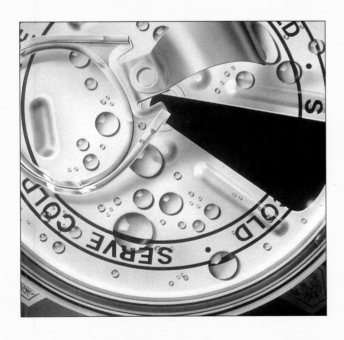

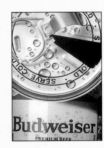

**BUDWEISER (detail)** BRIAN ROBSON

The familiarity of throwaway packaging such as this beer can deserves a second glance when the artist's skill focuses the range of visual detail. The cool tones of the silvery alloy exterior are contrasted with the gold lights of the interior surface, depicted in the upturned ring-pull resting on the can.

# PEWTER:
# BEATEN TEXTURE

The process of beating metal to form an indented or embossed pattern produces a variety of results, depending upon the size and shape of the tool used to carry out the beating and the amount of force applied to shape the surface texture. This example shows a pattern of broad circles lightly indented in the surface of pewter. This is a metal which itself takes on different surface effects, having in some forms a rich gray tone with blue highlighting, as shown here, but also capable of being polished to a pale gleaming surface similar to silver.

All of the metallic texture is created with the airbrush in this case; there are no special techniques of highlighting or adding surface detail. The pattern of dished circles is formed by repeated use of a loose acetate mask. A single shape is cut and sprayed in a pattern of closely-shaped formation, opaque pale color being overlaid on the initial gray tones and emphasized by final spraying of white highlights. Because the beaten texture is the element of primary interest in this exercise, the lettering is shown simply as heavy black lines engraved in the surface of the plaque.

Draw the logo and apply masking film. Cut and lift the masking from the letterforms and spray with solid black **1**. Remask with clean film when the color is dry **2**. Cut the shape of the plaque and outlines of the letters; lift the main rectangle of masking film leaving the letterforms masked: spray with bands of graded tone **3**. Overspray highlight areas with white **4**. Cut a roughly circular shape from a piece of acetate and lay it on the artwork **5**. Spray with light blue-gray to create a "dished" effect **6**. Repeat to form an indented pattern on the plaque **7**, then strengthen shadow areas. Spray with opaque white to bring up the highlights **8**. Remove the remaining masking film **9**.

5

6

7

8

9

# PITTED METAL: CORRODED TEXTURE

Despite their durable substance, certain types of metal can sustain surface damage of various kinds and such effects may be required in an illustration to provide realistic detail to an image or to indicate a mood of destruction and decay. The surface quality of the flaws in the material depends upon the original character of the metal and the cause of the damage. This example shows the pitted surface of an unpolished metal plate such as might result from acidic corrosion, an accidental, randomly distributed effect rather than a deliberately etched pattern.

While the basic technique of airbrushing is used to establish the smooth surface of the metal plate, the method of achieving the pitted texture uses an established technique of watercolor painting – lifting wet color with a dry brush – to solve the problem of creating a patchy and irregular surface quality. The sprayed color is wetted selectively and unevenly by dropping small puddles of clean water with a paintbrush, then the moisture is absorbed on a dry brush. To enhance the effect, shadowing in the pitted areas is emphasized by hand painting the dark tones.

Mask the image area and cut the outline of the metal plate. Lift the background masking and spray with solid black **1**. Remove the masking from the metal plate and spray lightly graded tone along the lower edges **2**. When the paint is dry, cover the edges with masking and spray a graded tone of blue-gray over the whole plate, from dark at the leading edge to lighter tone at the top **3**. With a paintbrush, shake drops of clean water onto the graded tone and allow them to dissolve the underlying color **4**.

50

Lift the excess water with a dry brush, leaving irregular-edged marks on the sprayed surface representing the pitted texture. Allow the surface to dry and spray a fine spatter of black over the gray tones **5**. Using a fine paintbrush, dot black paint into the pitted shapes to strengthen the effect of rough texture **6**. Use a scalpel blade to scratch back fine linear highlights around the leading edges of the pitted shapes **7**. When the effect is satisfactory, remove all remaining masking **8**.

PITTED METAL

# RUSTED METAL: BROKEN TEXTURE

Rusting is a typical sign of deterioration in certain metals, but its effect completely alters the visual character of the material, turning smoothness into coarse, broken texture and transforming the cool sheen of the surface into rough red and brown tones.

The basic technique used here to describe the rusted texture is a loose paper mask; in this case, a paper towel. This gives an irregular, soft edge which can be repeated to form the effect of ridges in the damaged metal surface. However, as it is an absorbent material, the loose mask will have to be replaced as the work progresses, since the fibers will absorb the sprayed color. The overlapping shapes created by the loose masks automatically build up a gradation of tones modeling the ridged surface.

The shadows and highlights are finely described, but since the rusted part of the metal plate no longer has a reflective finish, the highlights should not be pronounced. To achieve this, they are scratched out of the sprayed color to show hard-edged detail in white, then oversprayed with the rust tone to return to a closer tonal balance.

Draw the image in outline and cover with masking film. Cut along the edges of the metal plate and lift the lower section of the mask. Spray with solid black. When the color is dry, lift the masking film covering the metal plate and spray with graded tone **1**. Remask the area, leaving the edges of the plate exposed. Mix the rust color and use this to overpsray the exposed edges of the plate **2**. Remove the masking film from the main plane of the metal plate. Tear an irregular curve in a piece of paper towel or tissue and place this above the lower corner of the plate. Spray with the rust color **3**. Spray repeatedly to build up the tones, moving the mask to form an irregular pattern of graded tone **4**.

Spray a spattered texture over the rusted area to emphasize the roughness of the surface effect **5**. Emphasize the dark edges of the metal plate by outlining them with pencil **6**. Use a scalpel blade to scratch back the color above the shadowed ridges of the rusted effect, making fine, jagged lines **7**. When the modeling of the texture is completed, spray over the whole area with a light glaze of rust color to knock back the highlights **8**. Allow the color to dry and remove the remaining masking **9**.

5

6

7

8

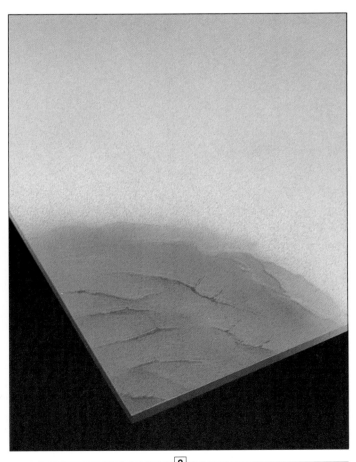

9

R U S T E D   M E T A L

**TRACTOR WHEEL** JONATHAN MINSHULL

A vigorous representation of painted metal which has been cor-
roded and discolored by exposure to the elements exploits distinc-
tive contrasts of tone and texture. The strength of the image also
depends upon the arrangement of strong abstract shapes,
defining the different planes of the metal objects and details such
as the bolts in the damaged ironwork.

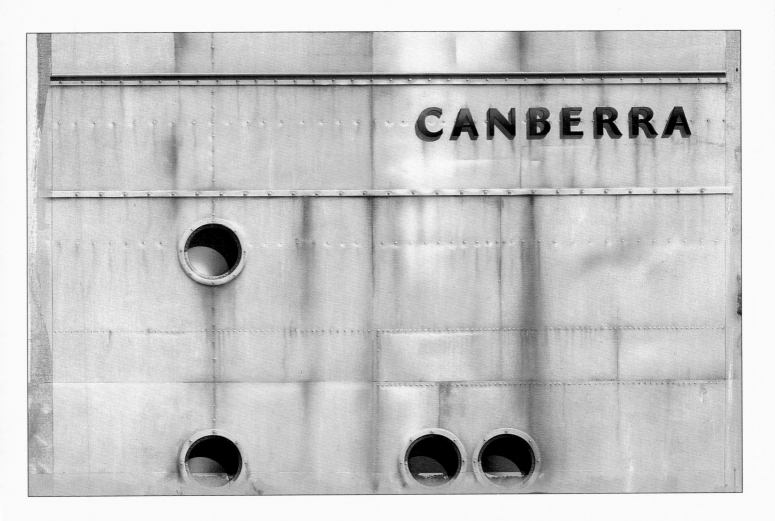

**CANBERRA** TOM STIMPSON

This is an example of an image in which airbrushing contributes a specific element of the surface detail, but as an adjunct to other painting techniques which in themselves define particular textural qualities. The details of the ship's side were applied with a brush on canvas board and glazed over with airbrush spray to model the final effects of tone and color.

## METALLIC FOIL: FORM AND CONTOUR

The flexibility of metallic foil provides a range of different effects, from the brittle, mirror-like surface of a perfectly smooth sheet of foil to the complex pattern of sharp-edged creases caused by crumpling the material. When rendering a section of creased and folded metal foil a detailed drawing is an essential first stage, as in this example, and a careful plan of the pattern of tonal values which describes the irregular contours of the surface. A high degree of tonal contrast is distributed over subtle curves and harsh angles, creating hard-edged shadows and gently modeled graded tones.

The example shown in this picture sequence can be followed as an exercise in airbrushing technique and an analysis of the range of tones and colors which reproduce the particular characteristics of the subject. But since metal foil is an inexpensive and readily available material, an original rendering can be made from direct observation. Where the effect of metallic foil is included in a more broadly based illustrative image, it is the relatively small details of highlighting and reflected color that give conviction to the subject in the particular context.

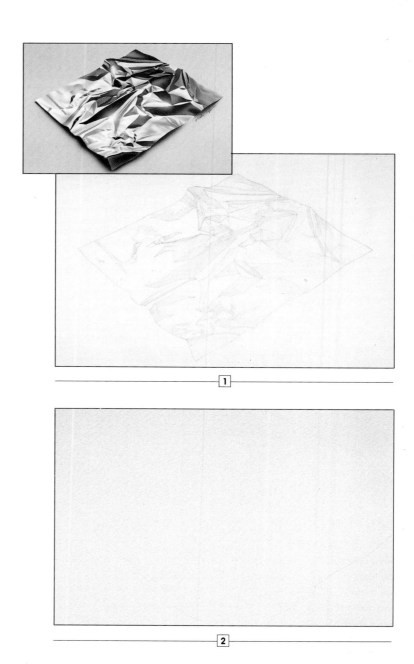

1

2

3

4

Remove the remaining masking film and place a fresh mask over the whole image. Cut along all the lines of the drawing showing the folds in the foil **5**. Lift the sections of masking covering the areas of the image to be sprayed with the darkest shadows. Spray with a dark, neutral brown mixed from sepia and black, forming hard edges against the mask and grading the tones outward **6**.

5

6

Draw up the full image on tracing paper, showing the outlines of all the folds and creases and the main areas of dark tone **1**. Transfer the main lines of the image to artboard, cover with masking film and cut the outline **2**. Lift the background masking and spray black shadows below the front edges of the foil **3**. Spray a uniform blue-gray tone across the background **4**.

METALLIC FOIL

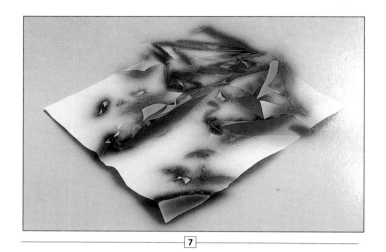

7

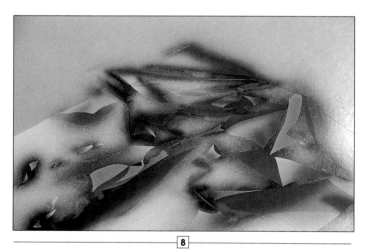

8

Remove the sections of masking film from the areas of mid-tone which have hard edges on each side, forming a series of irregular shapes across the image **9**. Mix the sepia colour with blue to form a cooler tone of gray-brown. Clean the airbrush and charge it with the fresh color, and spray mid to light tones **10** following the overall pattern of light and shade.

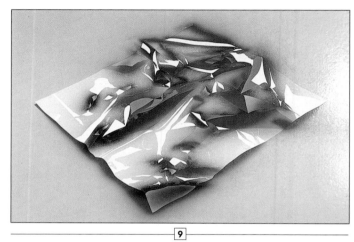

9

Following the same process, lift the masking from the mid-toned areas and spray graded tones of the same dark brown **7**. Refer to the final image on page 61 to identify the variations of tone. Use the mask sections to create a contrast of hard and soft edges, spraying the densest areas of mid-tone against the masked edges and grading the tones across each area to model the effect of the folds and creases in the foil **8**.

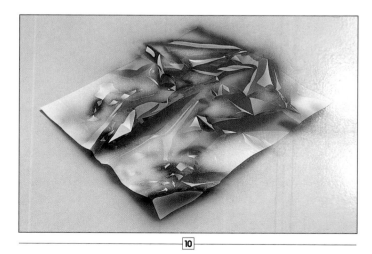

10

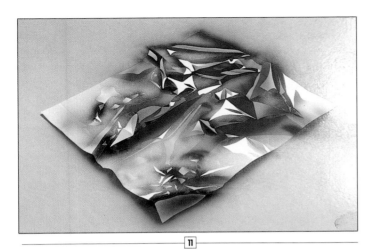

11

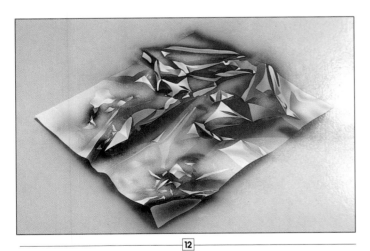

12

Remove all the masking from within the shape of the piece of foil, leaving only the background of the image masked out **13**. Using the blue-gray color mixed previously, spray freehand across the exposed sections of the image to apply soft, pale shadows giving a lightly shaded effect **14**. Grade off the spray to create white highlights on the ridges of the folds.

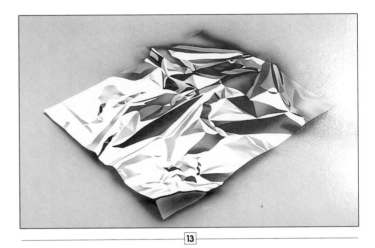

13

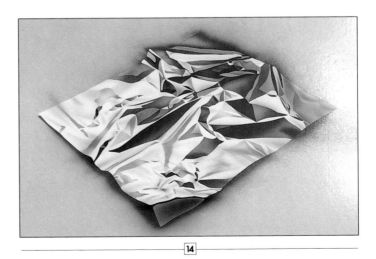

14

In the same way as in the previous step, lift the sections of mask representing the pale tones in the image, leaving the lightest areas still masked **11**. Slightly increase the blue content of the paint mixture and spray the pale-toned areas with graded color, making enough tonal variation to avoid a flattened effect in the individual planes of the crumpled foil **12**.

METALLIC FOIL

When the color is completely dry, remask the foil and remove the background mask. Referring to the balance of tones in the main image, strengthen the areas of shadow at the edges of the foil, spraying with a mixture of black and sepia **15**. Lift the masking film and use the edge of a scalpel blade to scratch back fine linear highlights along the edges of the main folds **16**. To create the effect of dazzle on the high points of the reflective metallic surface, spray small bursts of opaque white **17**.

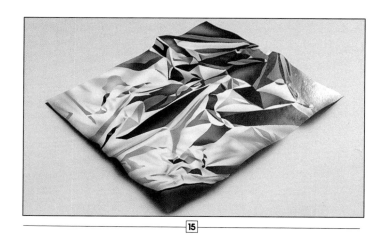

15

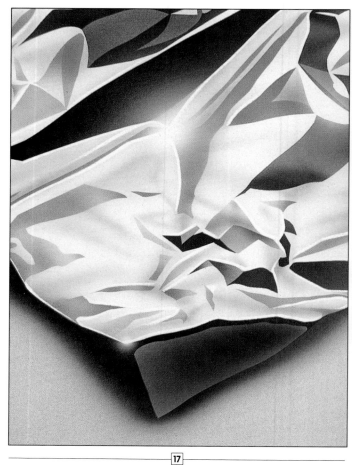

17

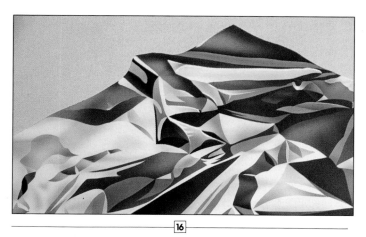

16

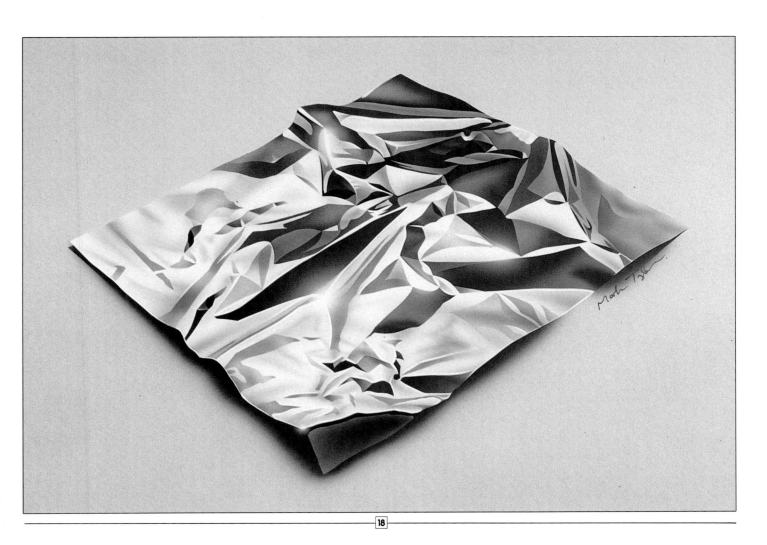

The final image **18** shows a balanced combination of hard and soft-edged tonal contrasts imitating the complicated structure and highly reflective surface quality of the piece of metal foil. The combination of a carefully planned masking sequence together with controlled freehand spraying in the later stages of the work provides the degree of technical variation necessary to render a very intricate and challenging subject. At each stage of spraying, when sections of the mask are removed, the whole tonal balance of the work should be reviewed to allow for any necessary adjustments. The final details of highlighting, using the scalpel method and spraying of opaque white gouache, must be carefully handled to give the surface polish to the image.

METALLIC FOIL

# GLOSSARY

**Acetate** A transparent film, produced in a variety of weights and thicknesses, used in airbrush work for loose masking and cut stencils.

**Acrylics** Paints consisting of pigments dispersed in a binding medium of synthetic acrylic resin, available in liquid or paste form.

**Artboard** A smooth-surfaced support particularly suitable for airbrushing as the surface allows a high degree of finish to graphic work and illustration. It is available in various thicknesses, flexible or rigid.

**Artwork** A graphic image or illustration of any kind, which may be intended for reproduction.

**Bevel edge** An edge or framing device at an angle of 45 degrees to a plane surface.

**Bleed 1** A ragged line of color caused by paint penetrating beneath the edge of a mask. **2** The effect of a color which shows through an overlying layer of opaque paint.

**Compressor** An electrically-driven mechanism designed to supply a continuous source of air to an airbrush.

**Dot highlight** A small circular highlight of opaque white paint, applied with an airbrush or fine paintbrush.

**Double-action** The mechanism of an airbrush which allows paint and air supplies to be separately manipulated by the airbrush user. In independent double action airbrushes, paint and air can be fed through in variable proportions, enabling the user to adjust the spray quality.

**Film masking** *See* Masking film.

**Freehand** The technique of airbrushing without use of masks.

**Gouache** A type of paint consisting of pigment in a gum binder and including a filler substance that makes the color opaque. It is a viscous substance and must be diluted with water to a fluid consistency for use in airbrushing.

**Grain** The surface quality of a material resulting from the texture of its constituent substance and the degree of surface finish.

**Hard edge** The boundary of a shape or area of color in an airbrush image which forms a clean edge between that and the adjacent section of the image. In airbrushing, this effect is produced by hard masking.

**Hard masking** The use of masks such as masking film or stiff cardboard which lie flush with the surface of the support and create sharp outlines to the masked shapes.

**Highlights** The lightest areas of an image, particularly special effects representing intense light reflection.

**Illustration** An image accompanying a specific text or depicting a given idea or action; often intended for reproduction in printed works.

**Ink** A liquid medium for drawing and painting, available in black, white and a range of colors; ink is categorized as a transparent medium.

**Keyline** An outline drawing establishing the area of an image and the structure of its component parts.

**Knock back** To reduce highlights or other light areas of an image, reducing the overall tonal contrast, by spraying over white areas and pale tones.

**Line highlight** A highlight applied to the edge or face of a plane of color by brush or ruling pen, by airbrushing or scratching back the paint.

**Logo** A design composed of letterforms or other graphic symbols.

**Loose masking** The use of materials such as paper, cardboard, plastic templates etc. as masks for airbrush work, which do not adhere

to the surface of the support and can be lifted or repositioned according to the effect required.

**Mask** Any material or object placed in the path of airbrush spray to prevent the spray from falling on the surface of the support. *See* Hard masking, Loose masking, Masking film, Soft masking.

**Masking film** A flexible, self-adhesive transparent plastic film laid over a support to act as a mask. The material adheres to the surface of the support, but the quality of the adhesive allows it to be lifted cleanly without damage to the underlying surface. This is the most precise masking material for airbrush work.

**Medium** The substance used for creating or coloring an image, e.g. paint or ink. *See* Acrylics, Gouache, Ink, Watercolor.

**Modeling** The method of using tone and color to render a two-dimensional image with an impression of three-dimensional solidity.

**Opaque medium** A paint capable of concealing surface marks, such as lines of a drawing or previous layers of paint. This is due to a filler in the paint which makes it tend to dry to a flat, even finish of solid color. *See* Gouache.

**Patina** A colored coating on the surface of metal, particularly copper, caused by natural weathering or chemical treatment.

**Propellant** The mechanism used to supply air to an airbrush. Cans of compressed air are available which can be attached to the airbrush by a valve and airhose, but a compressor is the most efficient means of continuous supply.

**Rendering** The process of developing a composition from a simple drawing to a highy finished, often illusionistic image.

**Reservoir** The part of an airbrush which contains the supply·of medium to be converted in spray form.

**Scratching back** The process of scraping paint from a support with a scalpel or other fine blade to create a highlight area or remove color when an error has been made.

**Serif** The terminal device on the end of a letter stroke, such as a tapered line or "tail."

**Soft edge** The effect of using loose masks or freehand airbrushing to create indefinite outlines and soften the transition between one area of an image and the next.

**Soft masking** The use of masks held at a distance from the support surface to soften the sprayed area, or a masking material which creates an amorphous effect, such as a cotton wool ball.

**Spatter** A mottled color effect of uneven spray particles produced by using a specially made spatter cap attachment for the airbrush nozzle, or by using the control button to vary the paint/air ratio within the airbrush.

**Tone 1** The scale of relative values from light to dark, visually demonstrated in terms of the range from black, through gray, to white, but also applicable to color effects. **2** Any given value of lightness or darkness within a picture or design, or in an individual component of an image.

**Transfer paper** A fine paper coated on one side with graphite or compressed powder color, which is inserted underneath tracing paper and when traced over, transfers the image to the surface below.

**Transparent medium** A medium such as watercolor or ink which gains color intensity in successive applications but does not conceal underlying marks on the surface of the support.

**Watercolor** A water-soluble paint consisting of finely ground pigment evenly dispersed in a gum binder. It is available in solid and liquid forms; liquid watercolor is the most useful type for airbrushing.

# INDEX

# CREDITS

**p17** Jonathan Minshull, courtesy of
Artists Inc; **p28** John Bretona; **p29** Bert
Warner, courtesy of Amber Below the
line; **p41** Andy Miles; **pp42-43** Andy
Miles, Pete Kelly (courtesy of
Meiklejohn Illustration) and Gavin
Macleod (courtesy of Meiklejohn
Illustration); **p47** Brian Robson,
courtesy of Meiklejohn Illustration;
**pp54-55** Jonathan Minshull, courtesy
of Artists Inc, and Tom Stimpson.

Demonstrations by Mark Taylor
Diagrams by Craig Austen